Kirklees
COUNCIL

Library and Information Centres

Red doles

Huddersfi

HD2 1YF

D1353914

This book should be returned on or before the lates
Fines are charged if the item is late.

TEEN

You may renew this loan for a further period by phone, personal visit or at
www.kirklees.gov.uk/libraries, provided that the book is not required by
another reader.

NO MORE THAN THREE RENEWALS ARE PERMITTED

800 694 013

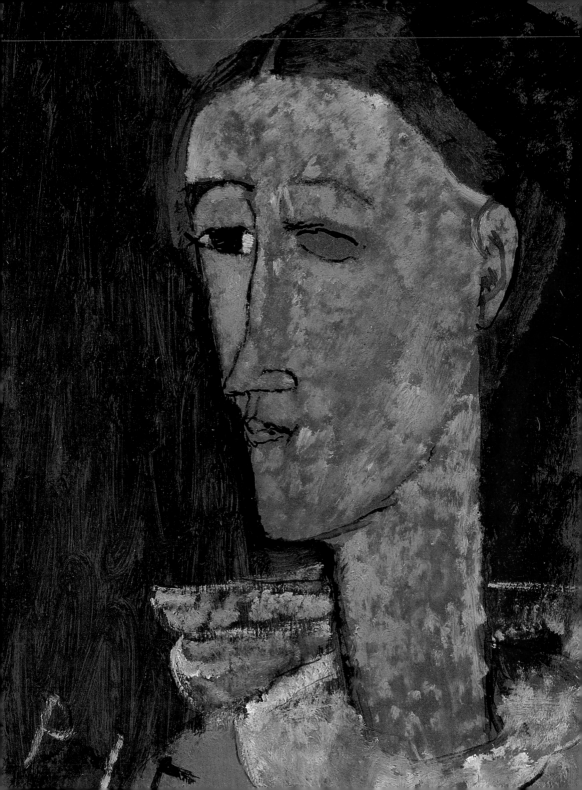

Amedeo Modigliani

Jonathan Vernon

Tate Introductions
Tate Publishing

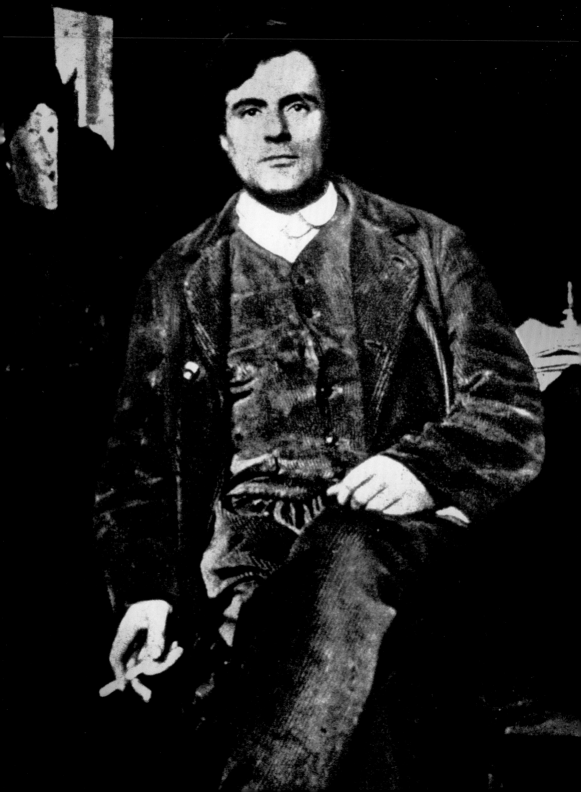

Amedeo Modigliani (1884–1920, fig.1) was born in Livorno, Italy, on 12 July 1884, the fourth child of Flaminio Modigliani and Eugenia Garsin.[1] The Garsins were a Jewish family whose roots, the artist would later, speciously, claim, could be traced back to the seventeenth-century philosopher Baruch Spinoza. The Italian-Jewish Modiglianis were of a less distinguished, but still prosperous, lineage. The family trade in wood and coal mining had originally furnished the painter's mother and father with a comfortable living but, by the time of Amedeo's birth, a series of business failures had placed them in financial difficulties.

A cultural upbringing

Although economically troubled, Modigliani's childhood was culturally rich. His maternal grandfather, Isaac Garsin (who moved in with his daughter's family when the artist was still an infant), was a cultivated man and guided Modigliani's first experiences of art and literature before his death in 1894. Eugenia's sister, Laura, was also particularly close to the family during Amedeo's youth. She is known to have given private language lessons to aid the family's income and also to have spurred the teenage Modigliani to devour an array of literature, from Italian classics to modern European philosophy. Most importantly, between 1900 and 1901 the artist's mother accompanied him, aged sixteen, on a tour of Naples, Capri, Rome, Venice and Florence. The trip had begun as an attempt to aid his recovery from his first bout of tuberculosis, the latest in a series of childhood illnesses he had suffered since the age of ten. By this time, Modigliani – who had expressed the desire to become an artist from a young age – had been studying with the landscape painter Guglielmo Micheli in Livorno for several years. It was while travelling in Italy, however, that he would gain the greater part of his education as an artist, and the work by Renaissance masters that he saw in the museums and grand palazzos

2. Life drawing
at the Académie
Colarossi in 1906

of the country's cultural centres became a point of reference to which
he returned frequently throughout his career.[2]

A native tradition

Shortly after touring the country with his mother, Modigliani left the
family home to establish himself as an artist, a journey that would lead
him to Paris by 1906, aged twenty-one. Several other coordinates
for his future career, and the position he came to occupy within the
School of Paris, were set in the intervening years. In Florence he
briefly studied with Giovanni Fattori, a member of the Macchiaioli
group, whose innovations in painting had anticipated those of the
French impressionists and evidently coloured some of Modigliani's
early works (see fig.20). In Venice he frequented circles shared by
Umberto Boccioni, later a leading exponent of futurism, and the artist
and writer Ardengo Soffici, who alternately decried and supported
the movement. After visiting the vast repository of ancient Greek and
Roman sculpture at the National Archaeological Museum in Naples,
he travelled to Carrara, a city world-renowned for its marble, and
attempted to apply the lessons of the ancients to his own carvings for
the first time.

 By the time of his arrival in Paris, Modigliani thus had every
opportunity to envision himself as part of a modern Italian tradition
built upon the foundations of antiquity and the Renaissance. Whereas
Boccioni and his futurist collaborators would turn against this concept
of tradition, the path charted by Modigliani's art and his invocations
of the Italian masters in later years served to extend and reiterate
it.[3] His education at the hands of those masters, especially at the
Uffizi, Pitti Palace and National Library in Florence, was evidently of
greater significance to the young artist than the more formal lessons

in anatomy and technique provided for him by the various *scuole* he attended in Florence and Venice, at which his attendance was always erratic.[4] Nevertheless, his later work would be informed by the opportunities these institutions provided to study the nude model from life, which Modigliani continued to seize at the independent academies he attended during his first years in Paris (fig.2).

Paris, 1906

In Paris, Modigliani would have been instantly immersed in a world of artistic and intellectual exchange, camaraderie and creative liberty unparalleled by his circles in Florence and Venice. By 1906, the city's primary centres of activity for independent artists, galleries and academies – principally Montmartre and Montparnasse – hosted a thriving network of young avant-gardes, many of whom were émigrés seeking the same opportunities as Modigliani. While he held the rare advantage of speaking French fluently, being foreign and Jewish at a time of considerable anti-Semitism, and lacking alternative means of support, Modigliani soon found himself living in a state of poverty from which he never truly escaped. However, as for many of the artists converging in Paris during these years, Modigliani was seeking out other riches to be found in the city's museums, galleries and salons: the work of the Impressionists and, in particular, the French Symbolists and Henri de Toulouse-Lautrec, whose influence on Modigliani's work of this period is overwhelming (see fig.21). The artist had begun a lifelong process of consuming, translating and synthesising the visual languages of his modernist peers and predecessors, and the strength and plurality of voices he encountered in Paris would immediately prove essential to discovering his own.

Cézanne's example

Modigliani's first real taste of public exposure in Paris came when he exhibited seven drawings at the Salon d'Automne of 1907. Also at the Salon was a retrospective devoted to Paul Cézanne, who had died the previous year. It included fifty-six works that represented the full, startling breadth of the elder artist's achievement, especially in his late works (fig.3). This exhibition was a pivotal moment for a generation of avant-garde artists who recognised Cézanne as the father of modern art. Traces of Cézanne's vocabulary of forms and handling of material

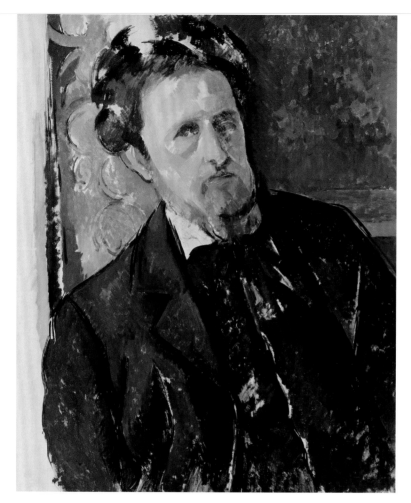

3. Paul Cézanne
Portrait of Joachim Gasquet 1896–7
Oil paint on canvas
65.5 × 54.5
Národní Galerie, Prague

4. *The Cellist* 1909
Oil paint on canvas
73 × 60
Colección Juan Abelló, Madrid

are especially evident in Modigliani's *The Cellist* of 1909 (fig.4). The lyrical echo of the musician's upturned nose and the F-hole of his instrument, the cylinder formed by his visible arm and the linear scaffolding of the space he occupies – all marshalled by an assured black line – produce structural harmonies calibrated according to Cézanne's example. Cézanne's mark can also be seen in the way in which many of the figures in Modigliani's later portraits occupy space, but the intensity of the master's presence in *The Cellist* would not be matched again until Modigliani's time in the south of France between 1918 and 1919 (see fig.54).

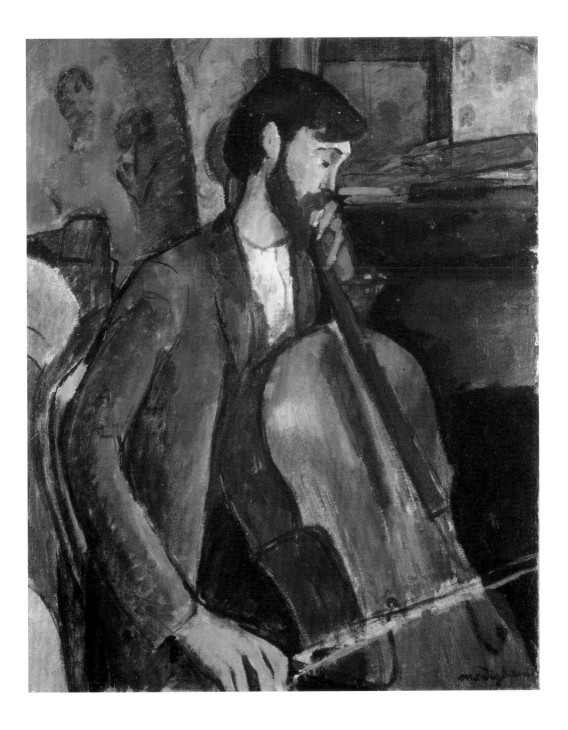

A sculptural group

The Cellist also provides a clue as to Modigliani's nascent interest in sculpture and the expansion of his artistic circle. On the reverse of the canvas is an unfinished portrait of the Romanian-born sculptor Constantin Brancusi – an artist who would play an enormous part in Modigliani's turn to sculpture between 1909 and 1914 (fig.5). The foundations of both this friendship and another vital relationship for Modigliani's early work were laid shortly after the Salon d'Automne. Having been forced to give up his first studio in Montmartre in the

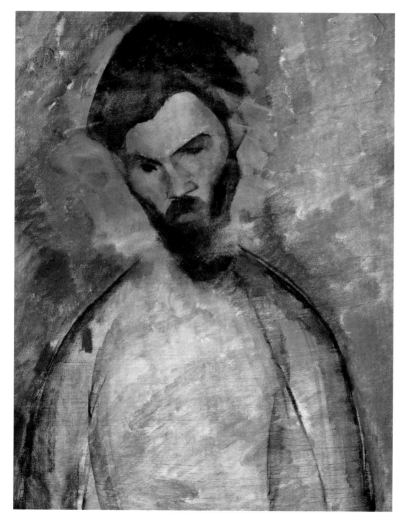

5. *Constantin Brancusi*
1909 (reverse of fig.4)
Oil paint on canvas
73 × 60
Abelló Collection

6. Constantin Brancusi
Baroness R.F.(*Head of a woman*) 1909
Stone
23.8 × 17.8
Centre Georges
Pompidou, Paris

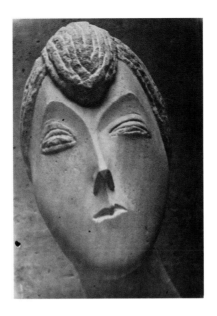

final months of 1907, Modigliani had the fortune of encountering the painter Henri Doucet in the famous bistro and gathering place for Montmartre's artists and writers, the Lapin Agile. Doucet brought Modigliani to a house on the rue Delta, the rooms of which were rented to artists by the doctor and collector Paul Alexandre. As Alexandre later reported, his rapport with Modigliani was instantaneous, as was the collector's interest in the young artist's work. He gave Modigliani his first commissions, for portraits of himself and his family, and began amassing a significant collection of his early work, totalling around twenty-five paintings and 450 drawings. Together Modigliani and Alexandre visited museums, exhibitions and artists' studios. As a result Modigliani met several figures who would prove important to his immediate development, such as the poet Max Jacob (fig.42), the Portuguese painter Amadeo de Souza-Cardoso and, finally, Brancusi.[5] By 1909, following a short trip back to Livorno, Modigliani had moved to the Cité Falguière in Montparnasse, rented a studio near to Brancusi's own and begun sculpting heads by carving directly into stone. Brancusi was almost unique in adopting this technique at the time, and its aptitude for simplified, idiomatic designs (fig.6) would heavily inform Modigliani's sculptural work.

Modigliani would go on to produce some twenty-eight sculptures – all *Heads*, but for two caryatids, and all in stone, but for one in marble and one in wood.[6] While his painting in this period (see figs.20–24) boasted a capability not yet channelled into a distinctive aesthetic, the drawings that informed his sculptural work would furnish his mature paintings with their characteristically elegant lines and stylised means of rendering a sitter's likeness (see figs.25–34).

Ancient and non-Western sources

Alexandre and Brancusi were a critical influence on the young Italian and the collective visual culture of their circle permeated his work. In Modigliani's portrait of Alexandre from 1911–12 (fig.7), for example, a column behind the sitter contains an ornamental scheme reminiscent of Brancusi's *Endless Column* (Museum of Modern Art, New York), a motif which had begun to appear in his carved bases at around the same time.[7] An African wall-hanging of Alexandre's has been suggested as a common source for both artists.[8] Alexandre himself would later attribute Modigliani's debt to African art – chiefly visible in the schematically drawn, shallow, elongated features of his sculptures – to frequent trips to the collections of non-Western art at the Musée d'Ethnographie du Trocadéro and the Musée Guimet, which the artist explored with Brancusi and Souza-Cardoso.[9]

The influence of non-Western sculpture had been evident in the studios of Montmartre and Montparnasse from the time of Modigliani's arrival. In 1906 Paul Gauguin's Salon d'Automne retrospective had sent shockwaves through the Parisian avant-garde – in particular the twelve wood carvings inflected by those he had seen in Tahiti. André Derain, Maurice de Vlaminck, Henri Matisse and Pablo Picasso (whose studio in the Bateau Lavoir Modigliani visited as early as 1906) had all begun to examine and acquire African objects that same year. The omnipresence of African sources in this moment, however, and the annexation of what was thought to be their expressive, 'primitive' power by the avant-garde, belie the fact that the idea of African art which held sway in Modigliani's circle was severely restrictive and selective. For example, Paul Guillaume (fig.44), who served as the artist's dealer from 1914 to 1916, was one of the most influential promoters of African sculpture in Paris at the time, and his taste was for simple objects with idiomatic designs and smooth, tautly

7. *Paul Alexandre* 1911–12
Oil paint on canvas
92 × 60
Private collection

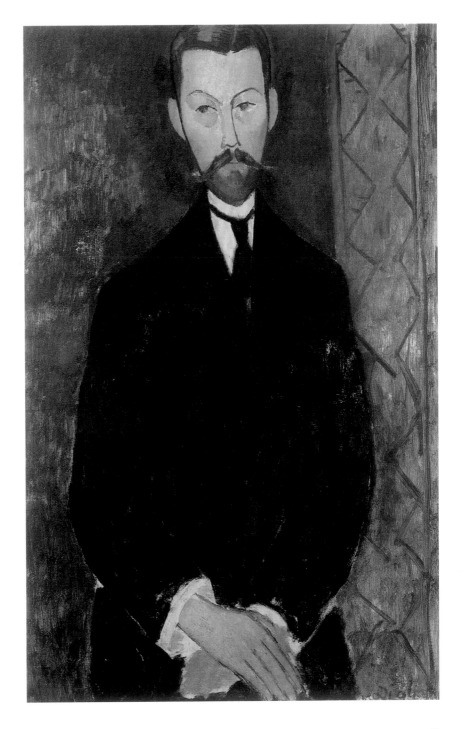

13

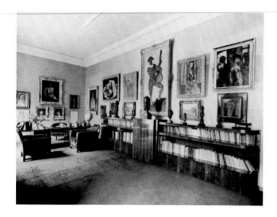

8. Paul Guillaume's apartment, 1930. Musée de l'Orangerie, Paris

stretched surfaces.[10] A photograph from 1930 shows Guillaume's bookshelf topped by a neat row of such objects and a wall heavily populated with canvases by Modigliani and a smattering of works by his contemporaries, including Picasso and Modigliani's close friend Chaïm Soutine (fig.8).[11] The impression created by such juxtapositions – that of a universal language of form binding modernism to its African precedents – is deceptive in its power and, all too often, constructed only in retrospect.

In fact, many of Modigliani's friends and contemporaries, such as the sculptors Jacques Lipchitz and Jacob Epstein, played down the role of African art in his sculpture, emphasising instead its debt to ancient sources.[12] Indeed, it may be said that Modigliani drew upon the aesthetics of African sculpture precisely because it was compatible with a classical sense of refinement, poise and mystery. Significant though the importation of non-Western art to Paris in this period was, the early twentieth century was also the age of great excavations, and the museums of Paris possessed a catalogue of freshly unearthed antiquities that Modigliani and his contemporaries could access freely.[13] The Egyptian, Greek, Roman and Etruscan sculpture that he had first encountered during his travels in Italy, and now visited often in the Louvre, charged Modigliani's sculpture with both its basic forms and spiritual essence. An Egyptian inflection is especially apparent in the frontality, linear design and neutral expressions of many of his *Heads*, as well as their being carved chiefly in limestone (which may have also resulted from financial imperatives, given its cost relative to marble). Modigliani's multiple drawings and

9. *Head* 1911–12
Limestone
Fundação Calouste
Gulbenkian, Lisbon

10. The 'Salle cubiste'
at the Salon d'automne
of 1912

sculptures of caryatids (figs.29–31,33,34), figural Greek architectural elements that Brancusi had also adapted in his sculptures by around 1908, and their often roughly-hewn surfaces betray an interest not only in the grand architectural schemes from which these sculptures originated, but also in their condition as fragments in the museum.[14] Although Modigliani had a clear propensity for direct confrontations with the original sources, his own vision of the classical figure, as with his interpretation of African art, would have been mediated by those of his contemporaries, such as the Polish-Jewish sculptor Elie Nadelman, his friend Lipchitz, compatriot Boccioni and others.[15]

Considering how the sculptures were seen, and the values they were seen to project, in Modigliani's time further emphasises that his idea of the past was filtered through the shared language and ideas of his milieu in the present. Epstein recalled of a visit to Modigliani's studio in 1912 that a number of *Heads* were mounted with candles, creating the impression of 'a primitive temple'.[16] A sense of the arcane – already present in the impassive *Heads*, their expressions as unyielding as the stone itself – may also be inferred from photographs documenting what may be a private exhibition of his sculptures organised with Brancusi and Alexandre's help in 1911, possibly held in Souza-Cardoso's studio (fig.9).[17] Perhaps the most significant display of Modigliani's sculpture during his lifetime, however, was at the 1912 Salon d'Automne (fig.10), where seven *Heads* on vertical white plinths were displayed under the collective title *Heads, decorative ensemble*, alongside a sculpture by Alexander Archipenko and against a backdrop of cubist paintings by František Kupka, Francis Picabia, Jean Metzinger and Henri le Fauconnier.[18] Although they do not conform

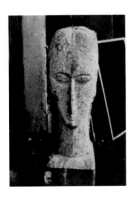

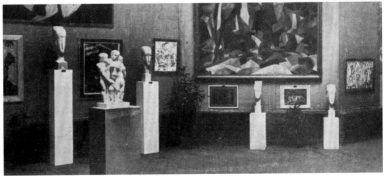

to the principles of cubist sculpture, Modigliani's *Heads* nonetheless resonate with these painters' contemporary interest in the languages of the occult and classical mythology, exhibiting as a group titled the 'Section d'Or' (or 'golden ratio') and appealing to the myth of Orpheus as an archetype for art's capacity to exercise a mystical control over the world. In this context, Modigliani's 'decorative ensemble' may be seen to evoke in purely conceptual terms what his candlelit sculptures achieved atmospherically – the suggestion of a 'Temple of Beauty' constructed according to the principles of a timeless order.[19]

A new milieu

The physical labour required by stone carving, Modigliani's deteriorating health and, perhaps, his exhaustion of the possibilities that had driven his sculptural activity led to its cessation in 1914.[20] Alexandre was conscripted the same year but, by 1916, the artist had found a new dealer, the Polish poet Léopold Zborowski (fig.11). Although Alexandre continued to sell his work, Zborowski offered Modigliani a business arrangement that was still novel in the Paris art

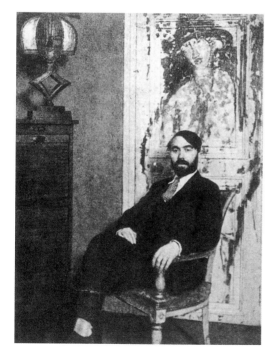

11. Léopold Zborowski in his apartment, c.1917

world, and largely confined to the artists and dealers at its margins. Zborowski paid for Modigliani's materials and living expenses, and also put him up in his own apartment building at 3 rue Joseph-Bara in Montparnasse, in exchange for the artist's entire output. Modigliani became close friends with Zborowski and his partner Hanka (also known as Anna), and painted both their portraits on multiple occasions (figs.45,46). By this time, Modigliani had established a close circle of friends in Paris, which included fellow Jewish painters Soutine and Moïse Kisling (fig.49). Both were also represented by Zborowski, with the latter keeping a studio alongside Modigliani's.

These years can be considered the beginning of the mature phase of Modigliani's career, with many of his finest and most important portraits dating to 1916 (figs 45,46). It was also at this point that Zborowski commissioned him to paint a series of nudes and, by 1919, he had produced thirty-five such works. They were chiefly painted in his studios at rue Joseph-Bara and, later, 8 rue de la Grande-Chaumière, with models who were paid five francs for each sitting.[21]

The nudes

In addition to his years of training in the study of live models (see fig.2), Modigliani's concerted efforts to paint nudes from 1916 were preceded by a number of early attempts. Two such works, including *Nude Study* 1908 (fig.22), were exhibited by Modigliani at the Salon des Indépendants of 1908. Coarse and scratched against a dark ground, *Nude Study* was shown alongside *The Jewess* 1907–8 (fig.21), and in its taut poverty seems to borrow in equal measure from Picasso's Blue Period, examples of which Modigliani probably saw in the artist's studio in 1906.

The later nudes project an altogether different sensibility, as their initial reception makes only too clear. The only one-man show devoted to Modigliani in his lifetime took place in December 1917 at the Paris gallery of Berthe Weill, a prominent dealer of avant-garde art. The exhibition has become fabled for its supposed closure by police on the grounds of indecency, triggered – according to Weill – by a significant crowd gathering in front of the gallery's window to ogle a nude with visible pubic hair.[22] The interpretation of the exhibition's closure as evidence of an erotic presence in Modigliani's nudes so potent as to threaten public order is somewhat undermined by its reopening

without incident the following day.[23] Nevertheless, the question is raised by the inescapable carnality of the paintings themselves: to what extent might a special lasciviousness be attributed to Modigliani's nudes, and what could it have signified in his own time?

In part, the presence of pubic hair (see figs.47,48) in Modigliani's nudes functions, like their occasional flashes of jewellery and made-up faces, as a marker of their contemporaneity. The sitters are not merely ideals in the Renaissance tradition, but living models. On its surface, this disrupts a basic function of the historical nude: to manufacture a representation of ideal virtue and beauty, and offer these properties – along with the available, pristine body itself – to the viewer or patron. In addition to the presence of pubic hair and make-up, the way in which Modigliani's nudes are painted endows them with an emphatically material presence in an equally material world. They possess a weight, a volume and a proximity to the viewer, pressed so close to the picture's surface that the tops of their heads are sometimes cropped by the edge of the canvas, as in his *Reclining*

12. *Reclining Nude, Head Resting on Right Arm* 1919
Oil paint on canvas
73 × 116
Private collection

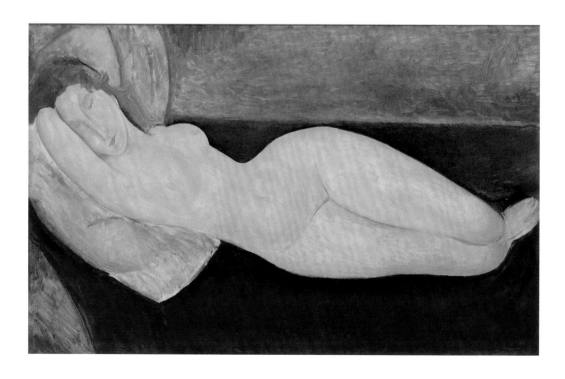

13. Giorgione
Sleeping Venus c.1510
Oil paint on canvas
108 × 175
Gemäldegalerie Alte
Meister, Dresden

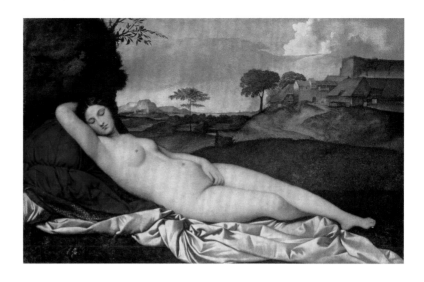

Nude with Loose Hair 1917 (Osaka City Museum of Modern Art, Japan). The scaled-up body of the monumental *Reclining Nude* c.1919 (fig.57) takes this visual strategy to its limit, and demonstrates how the black line delineating the contours of the body – adapted from the broken blue lines of Cézanne's still lifes, and developed through Modigliani's sculptural drawings – functions to release the abundant volumes contained within it. Finally, the presence of the model in many of Modigliani's nudes is secured by the assurance and power of her outward gaze, creating an exchange with the viewer that is openly mediated by desire.

Yet Modigliani's nudes also form an exchange with the grand traditions of the Italian Renaissance. Viewing certain of his reclining nudes (fig.12) alongside Giorgione's *Sleeping Venus* (fig.13) suggests Modigliani was sufficiently engaged with these precedents to quote from them directly. In addition to being familiar with such paintings from the museums of Florence, he is reported to have pinned reproductions of works by Titian, Correggio and Botticelli, each masters of the sensuous female nude, to his studio wall.[24] As with his sculptures, Modigliani translated these sources into a new visual language using the strategies of his modernist counterparts. The scholar Kenneth Wayne has noted that 'what kept Modigliani from being a fully-fledged cubist was most likely his interest in Old Master painting, specifically Italian Renaissance portraiture, and his

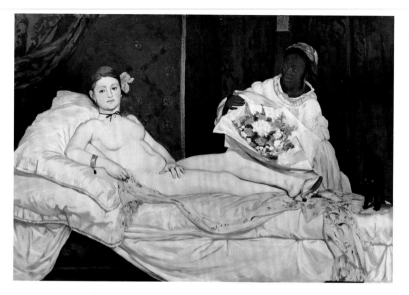

14. Édouard Manet
Olympia 1863
Oil paint on canvas
103.5 × 190
Musée d'Orsay, Paris

interest in being a Jewish artist'.[25] With regard to the artist's nudes, this should be qualified by the fact that in Modigliani's time the nude had become a testing ground for the Paris avant-garde to annex and adapt a figural tradition which had always been conspicuously rooted in the Italian Renaissance. The savagery of Picasso's *Les Demoiselles d'Avignon* 1907 (Museum of Modern Art, New York), for example, had been preceded by Matisse's *Blue Nude* 1906 (Baltimore Museum of Art) and Gauguin's *Manu Tupapau* 1892 (Albright-Knox Art Gallery, Buffalo) – works that all owed a debt to Manet's epochal *Olympia* 1863 (fig.14).[26] As the art historian T.J. Clark has shown, *Olympia* was the model of the self-conscious nude – solid, squalid and meeting the viewer's gaze directly. The hand on her thigh, like the pubic hair of Modigliani's nudes, draws attention to her genital area precisely by covering it. She is not nude, but naked; not a pictorial convention, but a woman living in the world.[27] All of this depended upon Manet's manipulation of a visual language in which Modigliani was fluent.

In determining the nature of Modigliani's nudes, it is important to recognise just how distinct they are, as both a category of works within his *œuvre* and in the context of the tradition's most recent iterations. Unlike a number of his portraits pre-1910 and post-1918, and unlike *Olympia*, Modigliani's nudes are largely placeless and

classless. While the interiors occupied by his sitters were often sparsely drawn, they are pushed even further into the margins of Modigliani's nudes by the body's insistent proximity to the viewer. The middle distance occupied by Giorgione's *Venus* or Manet's *Olympia* is collapsed, creating an intimately sensory, and sensual, experience. This might be seen to implicate the viewer in an act of voyeurism, and nominate the works themselves as pornographic. This is hardly precluded by the nude's historical lineage; indeed, images of sexually available, exotic female bodies posed and framed in such a way as to recall the nude tradition were widely circulated in Modigliani's Paris through the trade of erotic postcards (fig.15).[28] Several aspects of Modigliani's nudes, however, show their intimacy to be of a different order. The typical features of his nudes, their burnished complexion and dark hair, are attributable to the artist's preference for models of Italian, Jewish or North African origin. Modigliani tended to paint his thinner, fairer models in a vertical format, denying them the horizontal axis and reclining pose that characterise his most intense and accomplished nudes.[29] Although their features are mannered and classicised, evoking the Mediterranean archetypes of the classical and Renaissance worlds, they are also individuated. It may be that Modigliani was not only attempting to usher the ideal beauty of the Italian nude, and the humanist tradition it once represented, into the twentieth century but, as with his portraits, painting contemporaries of a comparable social status.[30]

15. Erotic French postcards were in regular circulation in the 1910s. Private collection

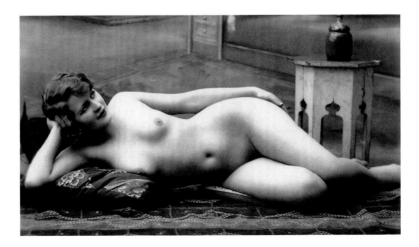

The portraits

Between 1913 and his death in 1920 Modigliani produced some 250 portraits, only three of which were double portraits (see fig.50). The remaining pictures chiefly depict single bust-length and three-quarter-length figures, closely cropped in tightly drawn interiors. Little is known of the artist's process, but he habitually produced preparatory drawings of his sitters and occasionally used photography.[31] While the artist's milieu is reflected in the fabric of these works, they are not consistently concerned with capturing the sitter's likeness or nodding, in the manner of historical portraiture, to their achievements through the signs of their profession or accumulated wealth. Conversely, while Modigliani's development as an artist is most visible in these pictures, they are never wholly exercises in style. One sitter may appear in such various guises as to be almost unidentifiable, and paintings made within months of one another may boast an entirely different set of visual strategies. Treated as a whole, however, Modigliani's portraits form a concentrated body of work – an essay in the representation of the figure and the study of human character, composed in a limited and personal language of forms.[32]

The evident impact on Modigliani's first portraits of the gaunt aesthetic developed by Picasso during his own early years in Paris, and its precedents in the art of Edvard Munch and Henri de Toulouse-Lautrec, marked only the beginning of Modigliani's entanglement with the young Spaniard. It was the circle of cubist painters, poets and radicals that gathered at the Café de la Rotonde in Montparnasse, which Modigliani began to frequent at the outset of the First World War, that supplied him with the sitters he required. They also gave him the impetus to drive towards a painterly idiom that synthesised his knowledge of tradition with the methods developed by the avant-garde. The stippled brushwork of his portraits of the cubist painters Diego Rivera (fig.35) and Frank Burty Haviland (fig.36) at once recalls the French fauves, late nineteenth- and early twentieth-century Italian divisionist painting and even his futurist compatriots. Moreover, the triangular composition of the portrait of Rivera, and the eddies of daubed marks rippling outward from his head, carry a faint echo of the cubist portraits produced by Picasso and Georges Braque in 1911–12.

These same paintings may have informed Modigliani's inclusion of inscriptions on the surfaces of his canvases, often stating simply the

16. *Madam Pompadour*
1915
Oil paint on canvas
61.1 × 50.2
Art Institute of Chicago

title of the work, a leading phrase – such as *'savoir'* upon his portrait of Picasso (fig.39) – or, in some of his drawings, quotations from Dante, Gabriele d'Annunzio and others.[33] On the whole such techniques never exceed the level of quotation in his work; they are tried on as lenses through which to see the figure, and cast off soon afterwards. The linear, faceted planes of his portrait of Max Jacob (fig.42) constitute the rather mild extent of Modigliani's cubism. Recalling Kenneth Wayne's claim that Modigliani's distance from cubism was marshalled not only by his affection for the Renaissance but also by his status as a Jewish artist, we might suggest that the latter informed his relentless focus on the human form. As the historian Emily Braun has noted, Modigliani was preceded by a strong tradition of nineteenth-century Italian-Jewish portrait artists, while other Jewish painters of this moment, including Soutine and Kisling, self-consciously referenced their heritage in their choices of subjects.[34]

Perhaps the most complex contributions to the development visible in Modigliani's portraits, and the perception that his mannered pictorial language was uniquely disposed to representing women, can be attributed to his two great companions and sitters: the English writer Beatrice Hastings and the artist and mother of Modigliani's only child Jeanne Hébuterne, who committed suicide while nine months pregnant with their second child upon Modigliani's death. Modigliani and Hastings were together from 1914 to 1916, and the keen intellectual and cultural sense that entrenched her within Modigliani's circle cannot be dismissed in accounting for the maturation of his painting during these years. His pictures of Hastings run the gamut of devices he was testing in his portraits of the time. As *Madam Pompadour* 1915 (fig.16) she is subjected to a judicious caricature, in the guise of King Louis XV's noted mistress, that substitutes likeness for a pastiche of her cultivation and refinement. Playing the impoverished jester to Hastings's courtly noble, that same year Modigliani represented himself as the tragicomic figure of Pierrot (fig.38), a popular trope (drawn from the Italian theatrical tradition of the Commedia dell'Arte) for Picasso and other artists in Paris during

18. *Portrait of the Artist's Wife, Jeanne Hébuterne* 1918
Oil paint on canvas
101 × 65.7
Norton Simon Museum, Pasadena

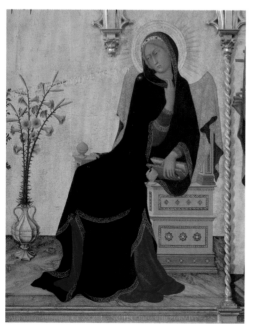

17. Simone Martini and Lippo Memmi
Annunciation with two saints-detail (*Virgin and vase of flowers*)1333
Tempera and gold on panel
305 × 265
Galleria degli Uffizi, Florence

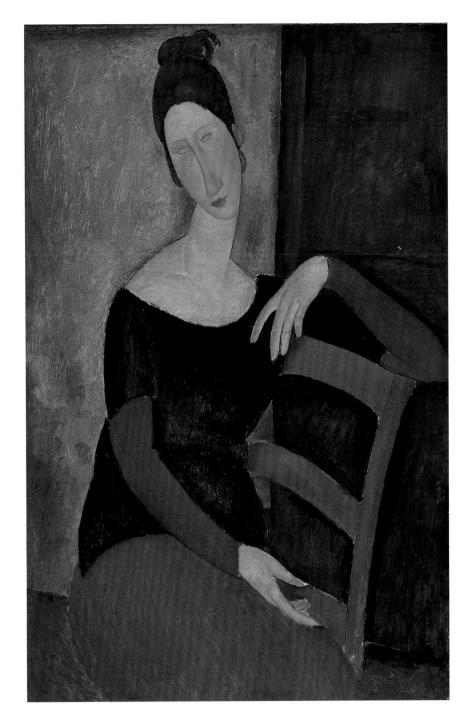

the period. In more tender portraits of Hastings (fig.37), a reserve and intelligence are captured in her pursed lips and sharp gaze.

Modigliani met Jeanne Hébuterne in 1917, and produced some twenty-five portraits of great variety (figs.55,58) that have nonetheless been understood as collective tokens of the artist's redemption in a perfect, loving and ultimately tragic union.[35] This is a confection, yet through his portraits of Hébuterne, Modigliani does seem to have arrived back at a sensibility channelling the Old Masters he had admired since his youth: a monumental stillness, a beatific calm, a state of grace. In a portrait of 1918 (fig.18) her gently tilted head and the delicate gesture formed by her hands against the curves of the body carry the resonance of Sienese painting (fig.17), an association deepened by the almond eyes and shallow, stylised features common to Modigliani's work of this period. Indeed, in paintings such as this we can see the essence of what the English painter Walter Sickert meant when he stated that 'Modigliani remains one of the noblest Romans of them all. There is always a certain sculpturesque grandeur in his paintings. They have the agreeable and welcome quality of very liquid fresco'.[36]

These qualities represent one fork of the divergent paths traced by Modigliani's portraiture in the last three years of his life. In the portraits of Hébuterne and Modigliani's other familiars, the faces and bodies of his sitters are funnelled with increasing severity into his circumscribed language of forms, and their settings are progressively abstracted into planes of rich colour. As with the late portrait of Hébuterne, architectural features tend to be sparsely drawn, the pictures' structure twisting to the curvilinear rhythms of his figures. Some of these portraits were produced during Modigliani and Hébuterne's time in the south of France from 1918 to 1919, where he had sought to escape at once from his own ailing health – the product of his worsening tuberculosis, exacerbated by excesses of alcohol and opium – and the German shells falling on Paris. At this time, however, he also produced a number of portraits of youthful local peasants which project increasing character and anchor them more firmly in their physical environment (fig.54) – a world of the same crystalline arboreal vistas and shaded café corners as those inhabited by Cézanne. He even painted a handful of Cézanniste landscapes. This is not only a matter of Modigliani's vision opening

outwards onto a landscape that, like the sitter's peasant dress (fig.56), aligned them with a different way of life. The concreteness of the figures themselves, achieved with a lighter touch and more earnest approach to that of his nudes, is an effect of patient tonal work endowing them with a sense of mass and presence that was entirely new to his portraits. Although these avenues of enquiry were to be abruptly cut off by the artist's death soon after, they nonetheless leave the impression, like the nudes and the sculptures, of a contained experiment in form and sensibility.

Conclusion

Upon Modigliani's death, aged thirty-five, on 24 January 1920, Lipchitz and Kisling made a death mask, which has since been recast in bronze. One such cast was photographed on a bookcase in Kisling's studio by André Kertész in 1933, propped frankly against the monograph written by the poet and critic André Salmon – another friend from the Café de la Rotonde – with the spine of a book devoted to Fra Angelico on one side and a reproduction of a late, Italianate portrait of Jeanne on the other (fig.19). The evidence of Modigliani's life and work places him in the same position – between his modernist contemporaries and the Italian masters. What persists through his syntheses of their example is the impression of a harmonic order, a constant drawing the past into the present.

19. André Kertész
Kisling's studio 1933
André Kertész Estate

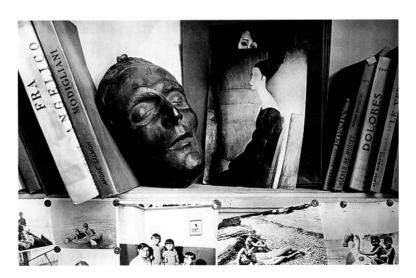

27

20. *Head of a Woman
in Profile* 1906–7
Oil paint on canvas
35.5 × 29.5
Private collection

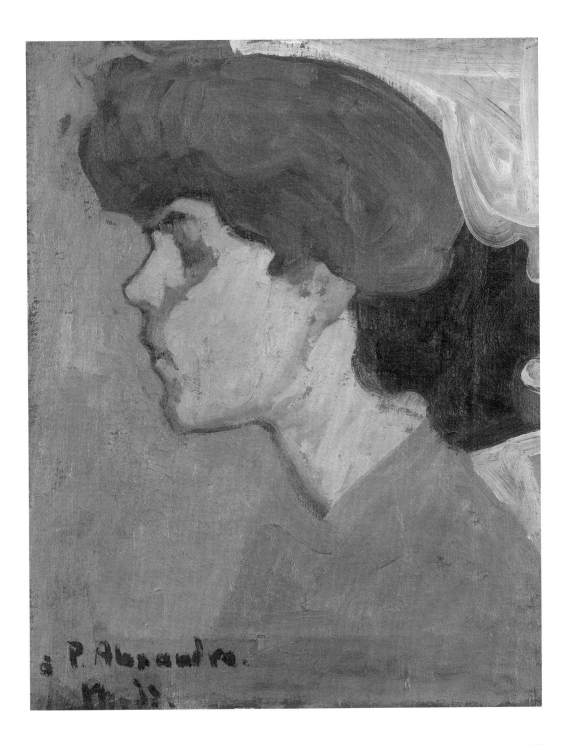

29

21. *The Jewess* 1907–8
Oil paint on canvas
54.9 × 46
Private collection

22. *Nude Study* 1908
Oil paint on canvas
81.9 × 54
Private collection

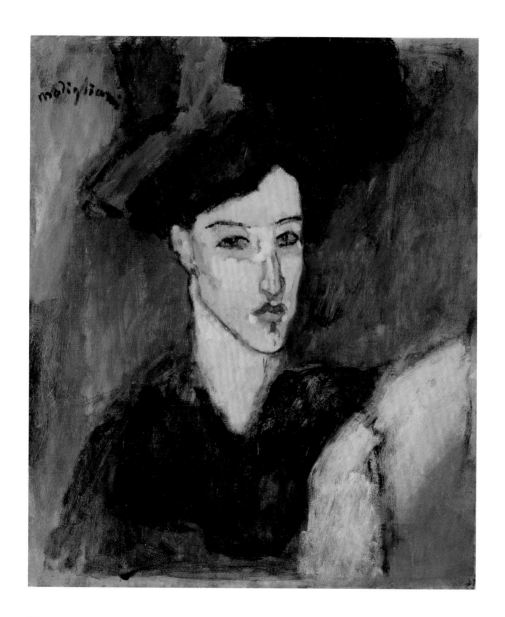

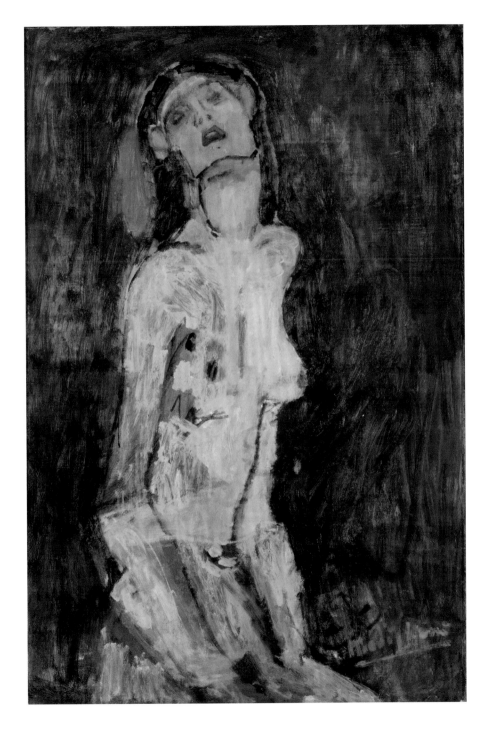

23. *Young Gypsy* 1909
Oil paint on canvas
81 × 54
Private collection

24. *The Amazon* 1909
Oil paint on canvas
92 × 65
Private collection

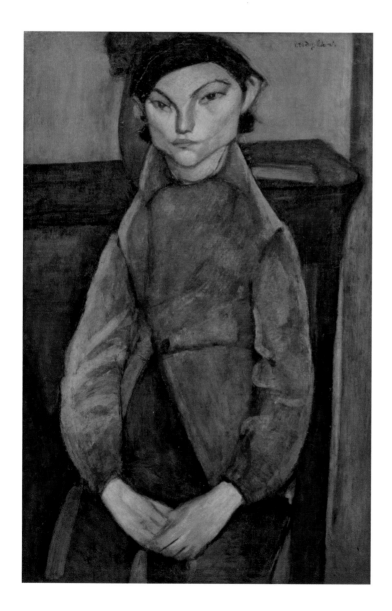

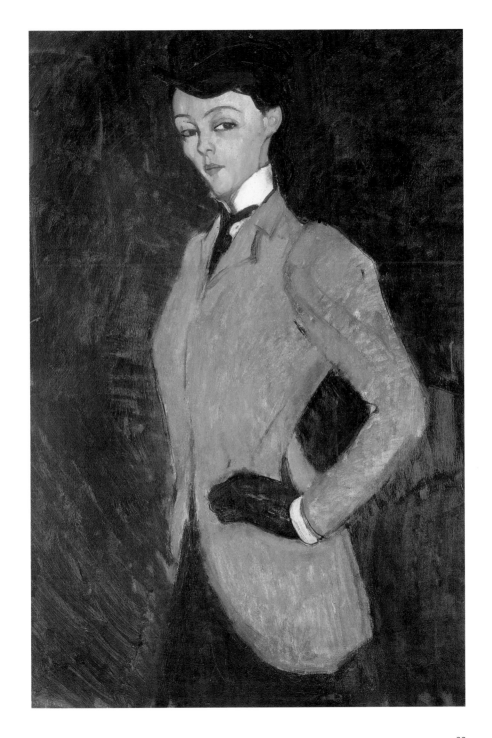

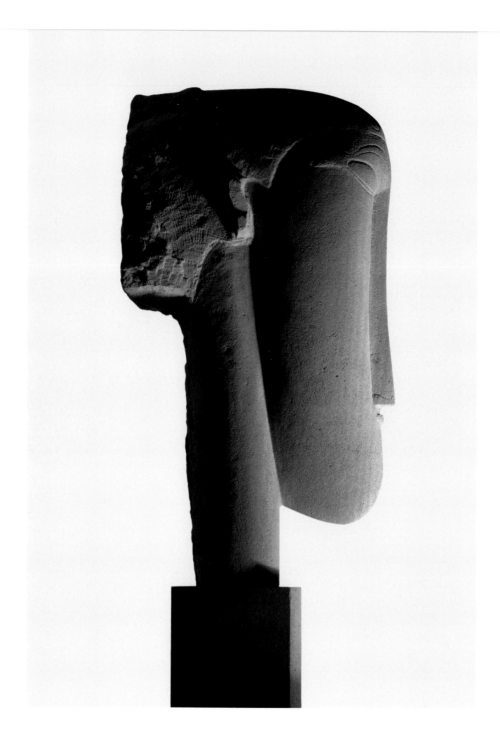

25. *Head* c.1911–12
Limestone
89.2 × 14 × 35.2
Tate

26. *Head of a Woman*
1911–12
Limestone
70.5 × 23.5 × 7.6
Philadelphia Museum
of Art

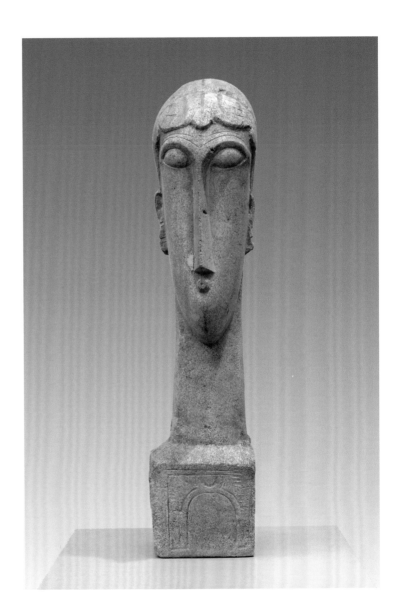

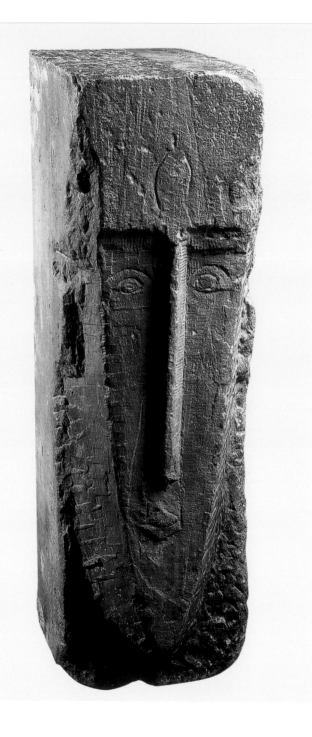

27. *Head* 1911–12
Stone
73 × 23 × 31
Private collection

28. *Female Head* c.1911–13
Stone
47 × 25 × 30
Centre Georges Pompidou,
Paris

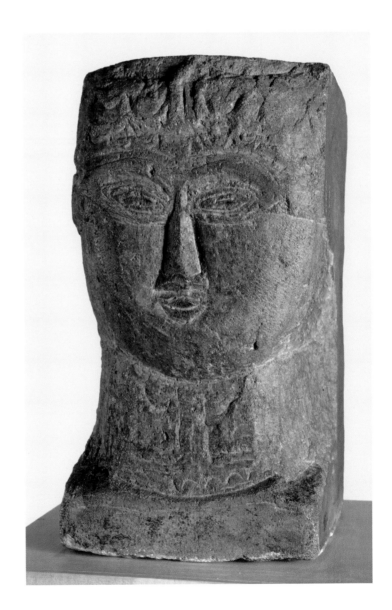

29. *Caryatid* 1913
Oil paint on canvas
81 × 45
Private collection

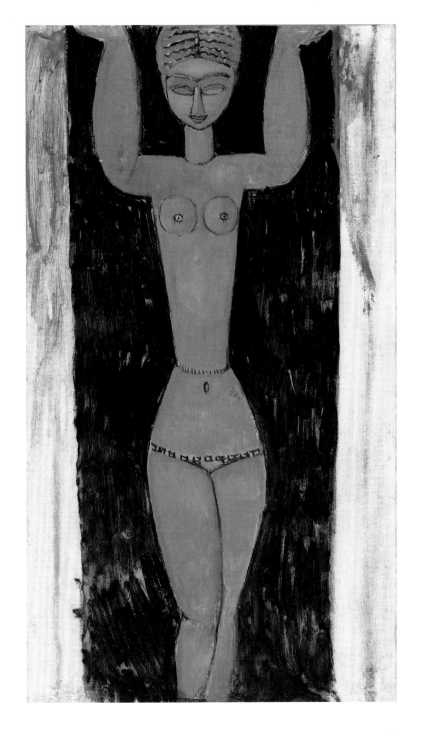

30. *Standing Nude* c.1912
Limestone
162.8 × 33.2 × 29.6
National Gallery of
Australia, Canberra

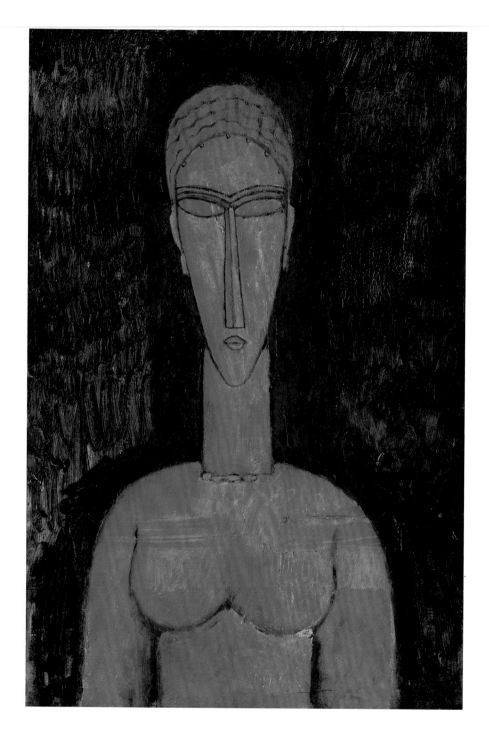

31. *Red Bust* 1913
Oil paint on canvas
81.2 × 53.3
Private collection

32. *Head* (*Portrait of
Beatrice Hastings*)
c.1913–14
White marble
58.3 × 20.5 × 27
Centre Georges Pompidou,
Paris

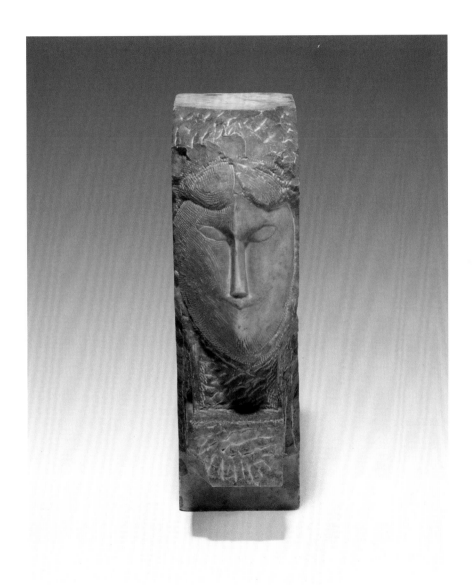

33. *Caryatid* c.1913–14
Graphite on paper
54.9 × 44.8
Tate

34. *Caryatid* c.1914
Limestone
92.1 × 41.6 × 42.9
Museum of Modern Art,
New York

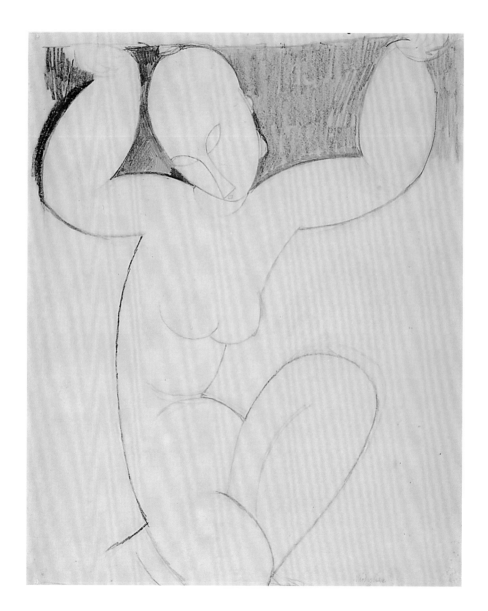

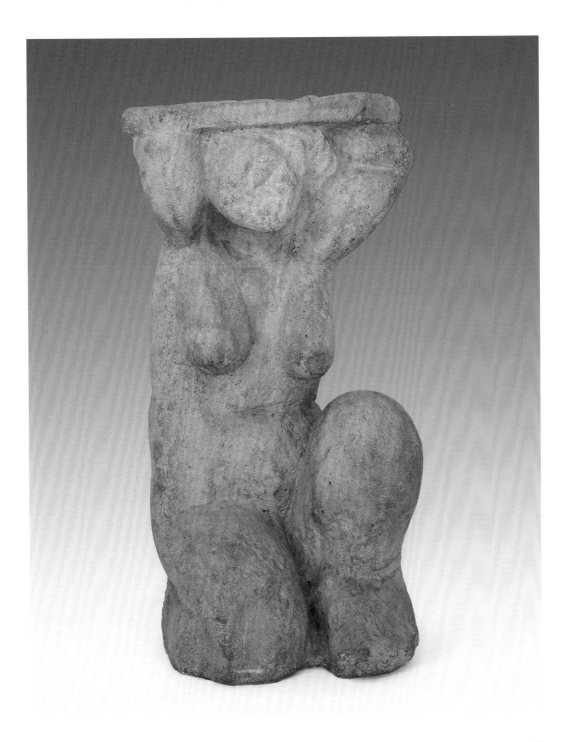

35. *Portrait of Diego Rivera*
1914
Oil paint on cardboard
104 × 75
Kunstsammlung-
Nordrhein-Westfalen,
Düsseldorf

36. *Portrait of the Painter
Frank Haviland* 1914
Oil paint on cardboard
73 × 60
Matolli Collection, Italy

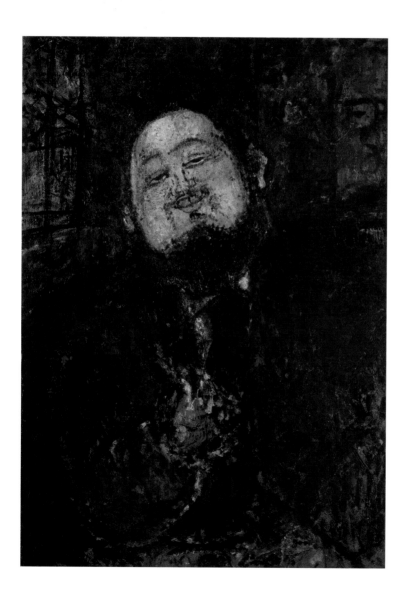

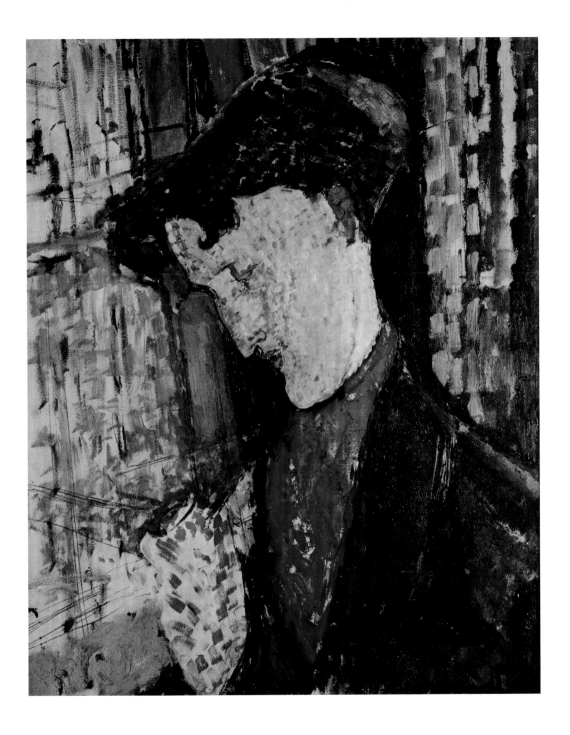

37. *Portrait of
Mrs Hastings* 1915
Oil paint on cardboard
55.5 × 45.4
Art Gallery of Ontario,
Toronto

38. *Self-Portrait as Pierrot*
1915
Oil paint on cardboard
43 × 27
National Gallery of
Denmark, Copenhagen

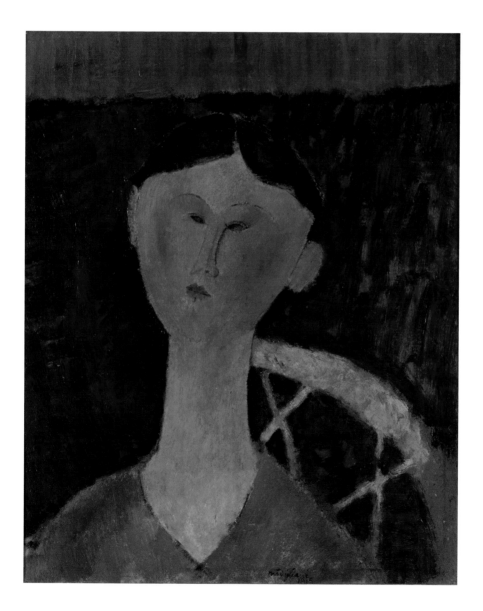

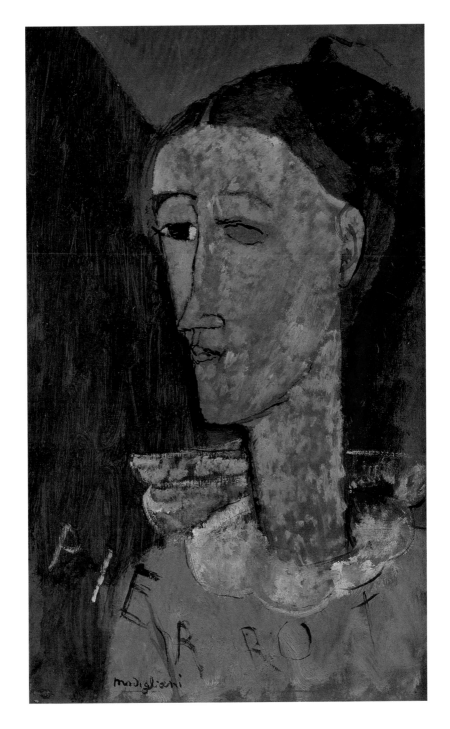

39. *Pablo Picasso* 1915
Oil paint on canvas
30 × 27
Private collection

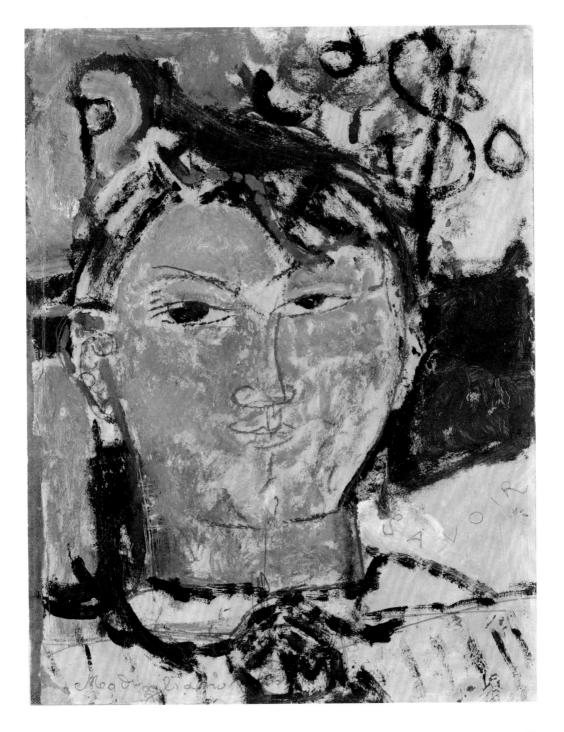

40. *Juan Gris* 1915
Oil paint on canvas
54.9 × 38.1
Metropolitan Museum of
Art, New York

41. *Léon Indenbaum* 1916
Oil paint on canvas
54.6 × 45.7
The Henry and Rose
Pearlman Foundation,
Princeton University

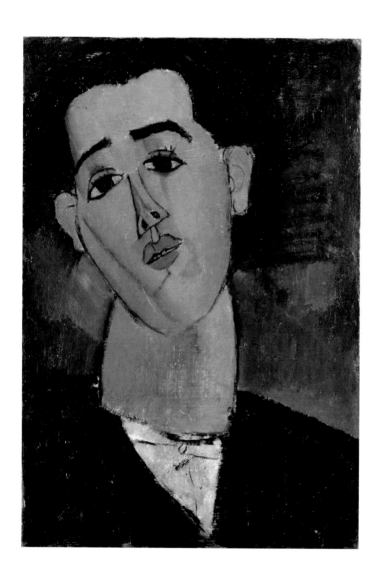

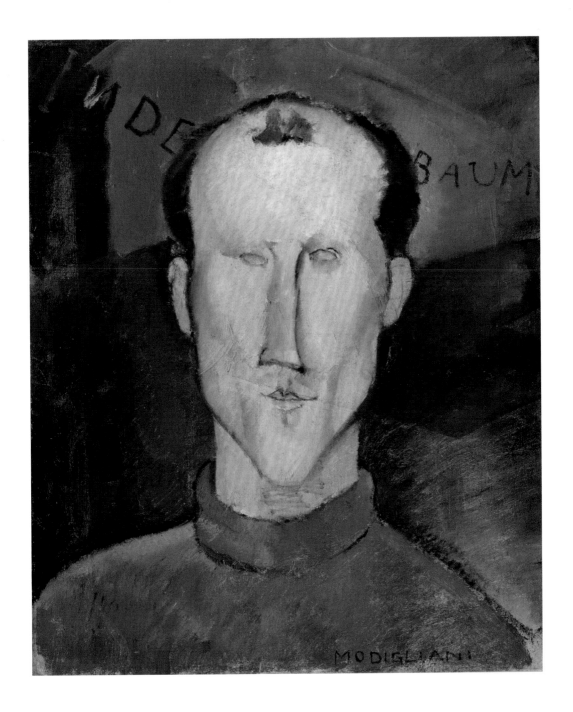

42. *Max Jacob* 1916
Oil paint on canvas
73 × 60
Kunstsammlung-
Nordrhein-Westfalen,
Düsseldorf

43. *Jean Cocteau* 1916
Oil paint on canvas
100.4 × 81.3
The Henry and Rose
Pearlman Foundation,
Princeton University

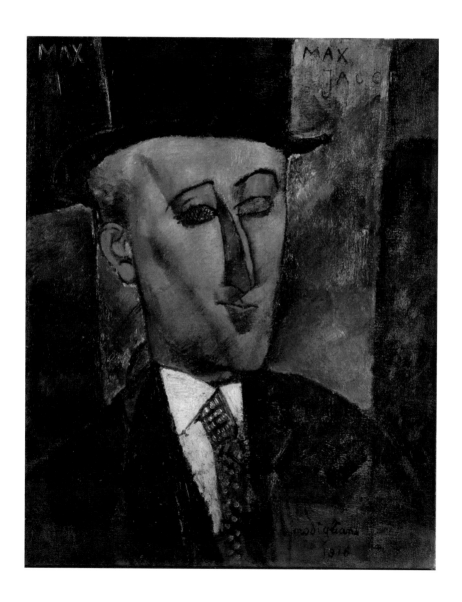

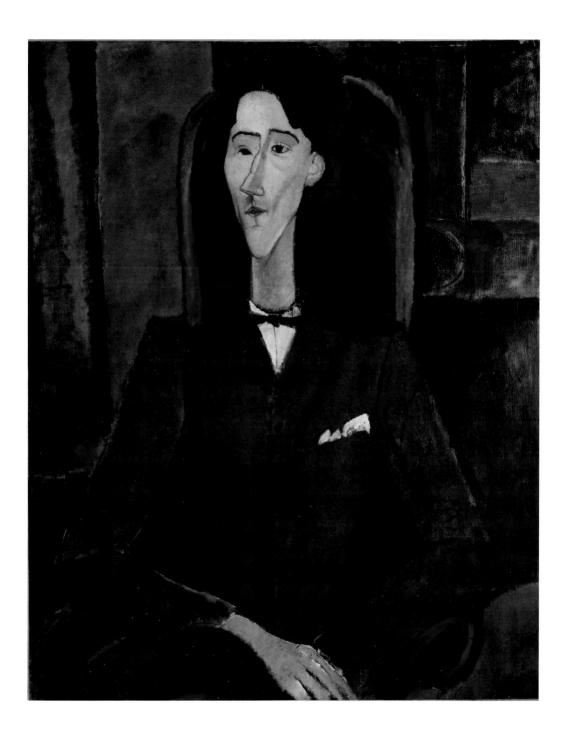

44. *Portrait of
Paul Guillaume,
Novo Pilota* 1916
Oil paint on card mounted
on cradled plywood
105 × 75
Musée de l'Orangerie,
Paris

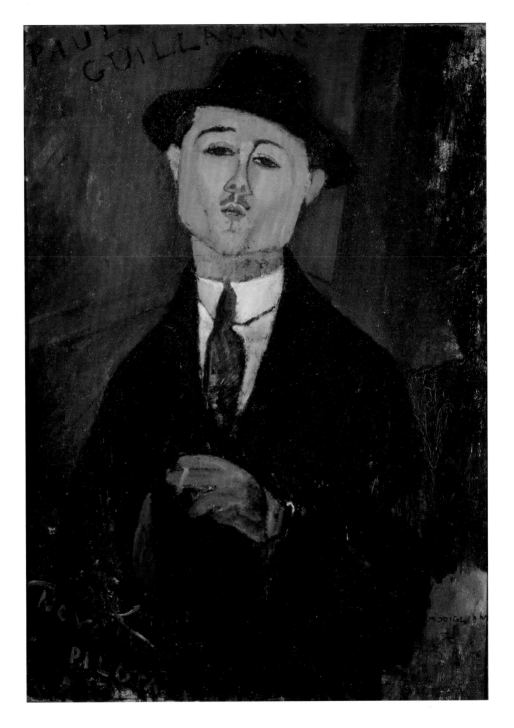

45. *Léopold Zborowski*
1916
Oil paint on canvas
65 × 42
Israel Museum,
Jerusalem

46. *Portrait of Anna
Zborowski* 1916
Oil paint on canvas
76.2 × 45.1
Private collection

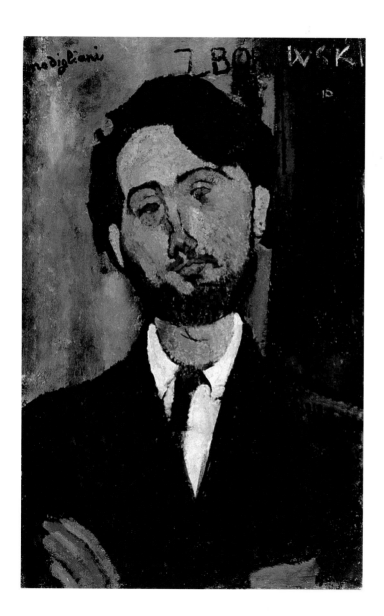

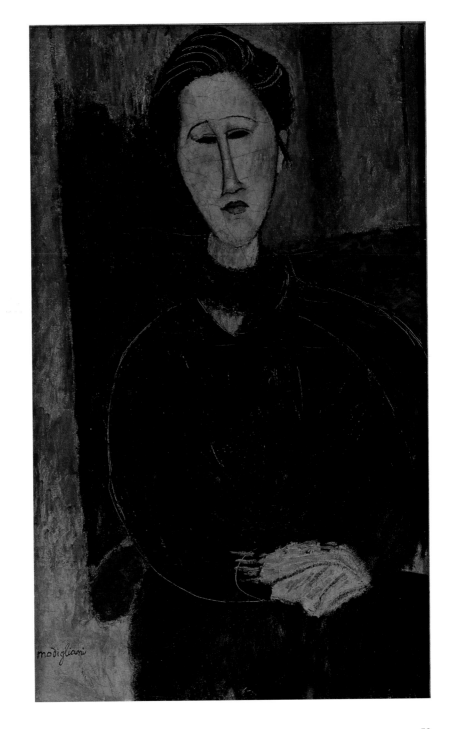

47. *Reclining Nude* 1917–18
Oil paint on canvas
59.9 × 92
Private collection

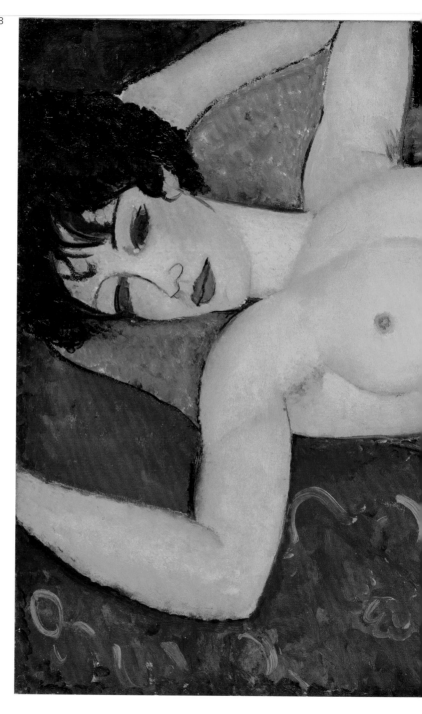

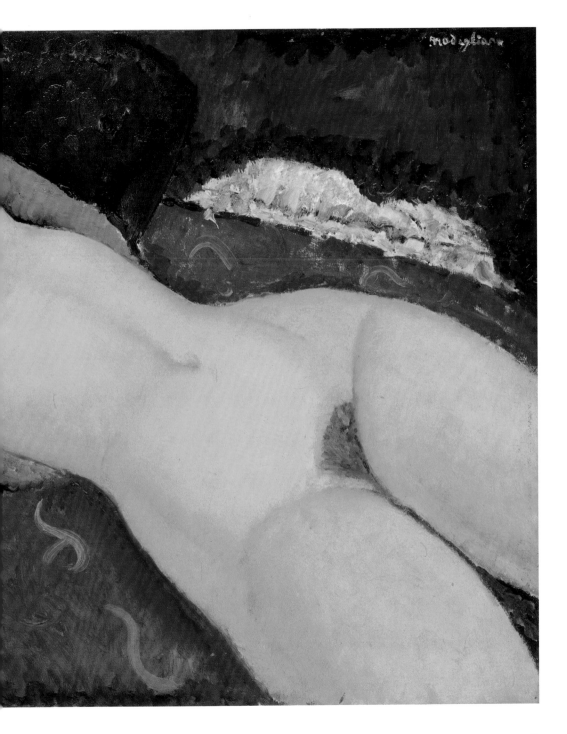

48. *Female Nude* c.1916
Oil paint on canvas
92 × 60
The Samuel Courtauld
Trust, The Courtauld
Gallery, London

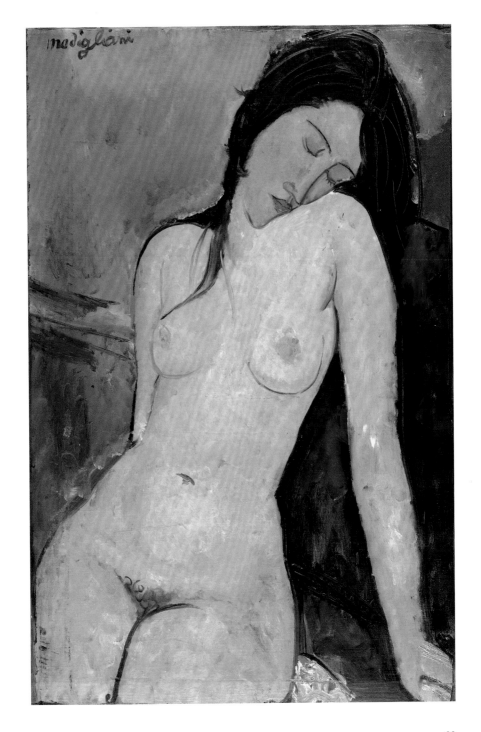

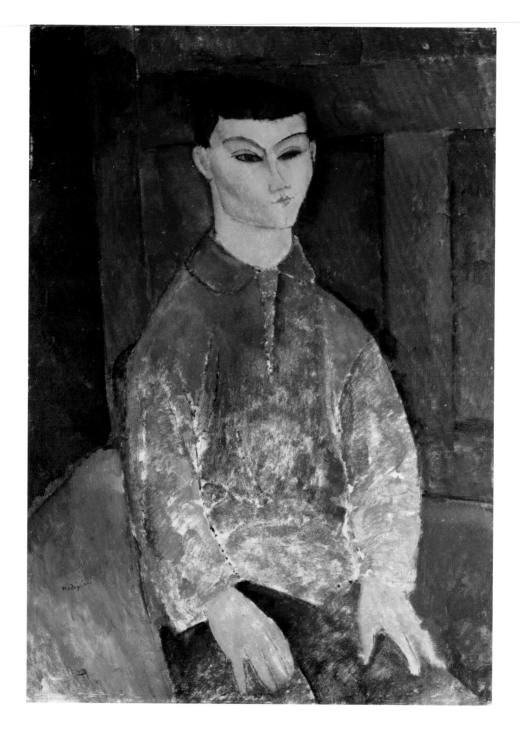

49. *Moïse Kisling
Seated* 1916
Oil paint on cardboard
104.8 × 74.9
Private collection

50. *Jacques and Berthe
Lipchitz* 1916
Oil paint on canvas
81.3 × 54.3
The Art Institute of
Chicago

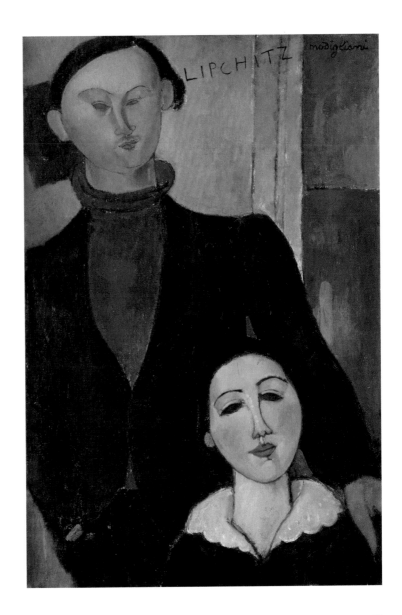

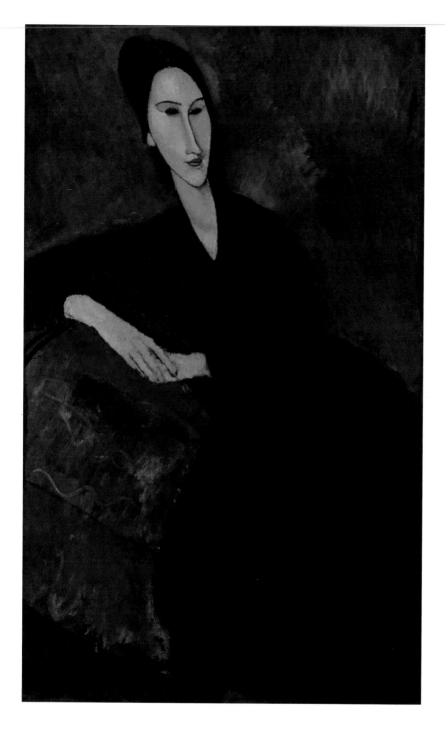

51. *Anna Zborowska* 1917
Oil paint on canvas
130.2 × 81.3
The Museum of Modern
Art, New York

52. *Portrait of a Girl* c.1917
Oil paint on canvas
80.6 × 59.7
Tate

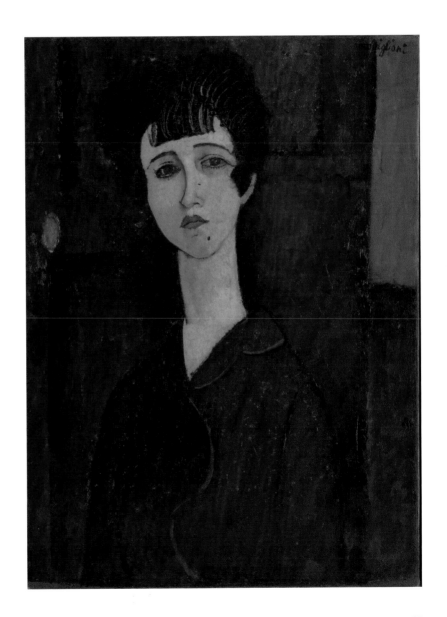

53. *Seated Nude* 1917
Oil paint on canvas
114 × 74
Koninklijk Museum voor
Schone Kunsten, Antwerp

54. *The Little Peasant*
c.1918
Oil paint on canvas
100 × 64.5
Tate

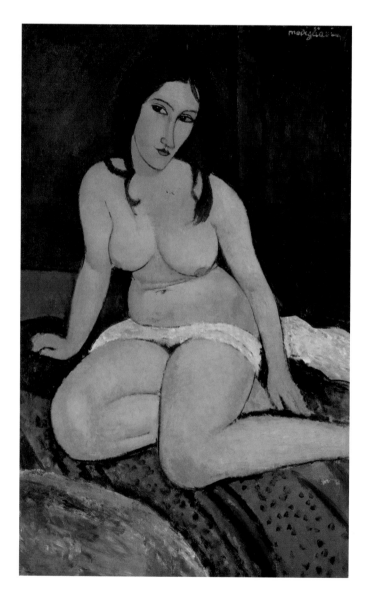

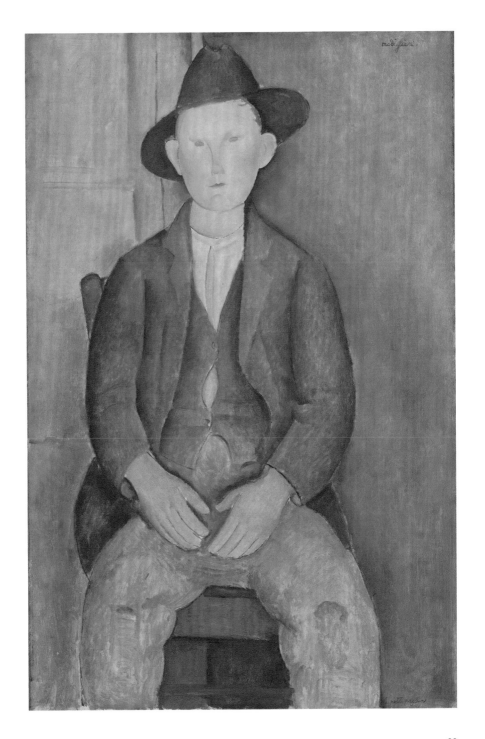

55. *Jeanne Hébuterne with Yellow Jumper* 1918–19
Oil paint on canvas
100 × 64.7
Solomon R. Guggenheim Museum, New York

56. *Gypsy Woman with Baby* 1919
Oil paint on canvas
115.9 × 73
National Gallery of Art, Washington, DC

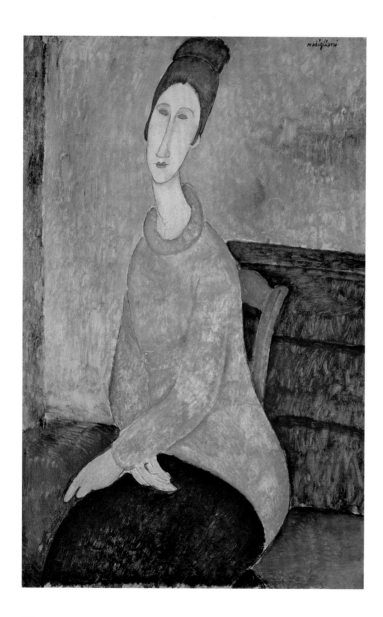

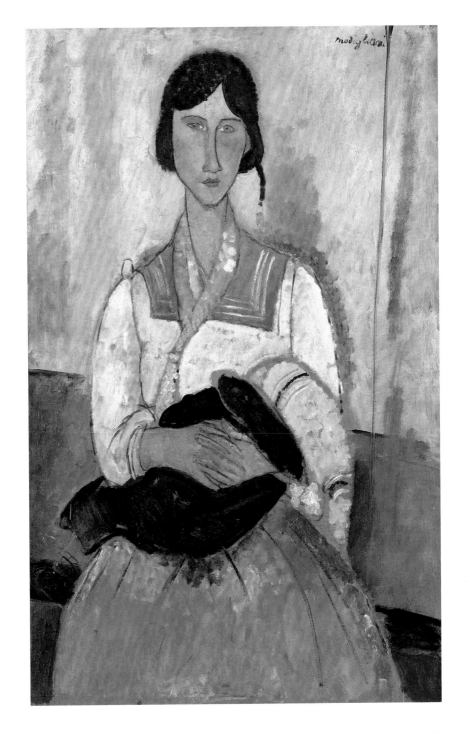

57. *Reclining Nude* c.1919
Oil paint on canvas
72.4 × 116.5
Museum of Modern Art,
New York

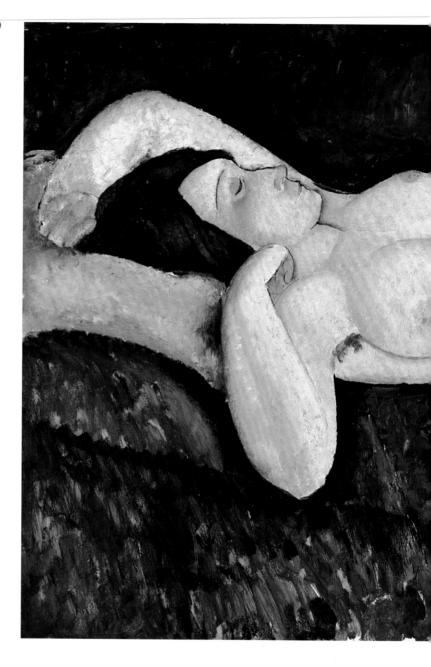

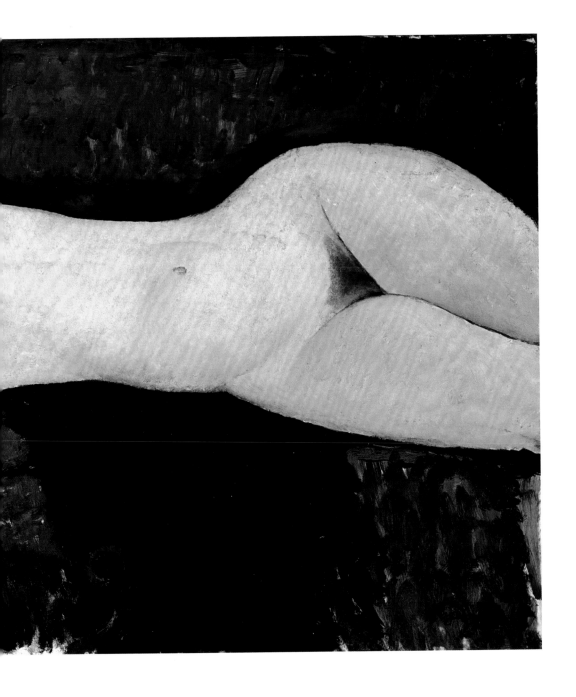

58. *Jeanne Hébuterne*
Seated 1918
Oil paint on canvas
92 × 60.3
Merzbacher Kunststiftung

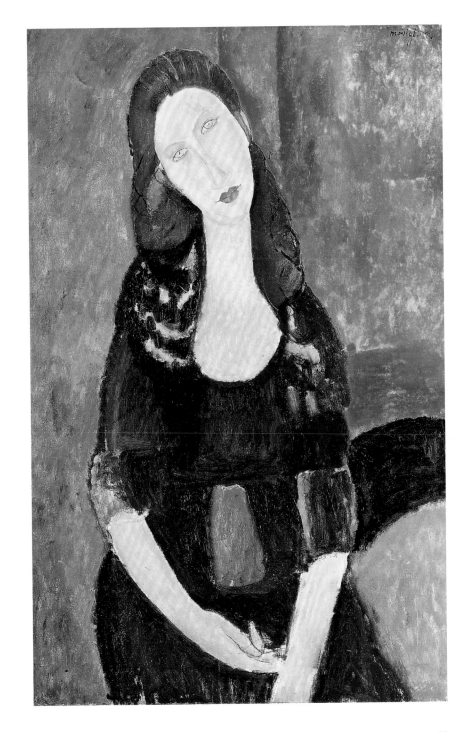

59. *Self Portrait* 1919
Oil paint on canvas
100 × 65
Museu de Arte
Contemporânea
da Universidade de
São Paulo, Brazil

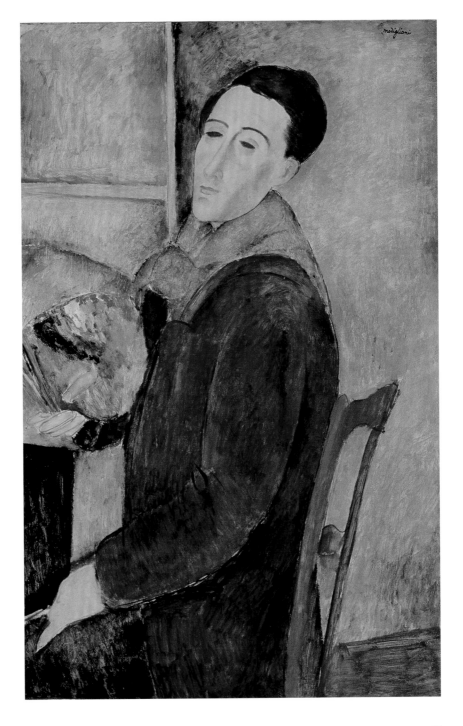

Notes

1. There are several comprehensive chronologies of the artist's life, including: Dolors Sala Fenés, 'Chronologie illustrée' in *Modigliani et l'Ecole de Paris: En collaboration avec le Centre Pompidou et les Collections Suisses*, exh. cat., Fondation Pierre Gianadda, Martigny 2013, pp.189–203; and Stéphanie Verdavaine, 'Chronology' in *Amedeo Modigliani: The Inner Eye*, exh. cat., LaM – Lille Métropole Musée d'Art Moderne d'Art Contemporain et d'Art Brut, Paris 2016, pp.166–74.

2. Much of the information about Modigliani's early life comes from the diary kept by Eugenia from 1886. Another valuable history of Modigliani's family may be found in the book of his illegitimate daughter, Jeanne Modigliani, *Modigliani: Man and Myth*, trans. by Esther Rowland Clifford, London 1959.

3. Marinetti's *Futurist Manifesto* – published on the front page of France's national newspaper *Le Figaro*, on 20 February 1907 – would call for the canals of Venice to flood the same museums that had nurtured the young Modigliani's passion for the masters, decrying them as 'cemeteries of empty exertion'. Filippo Tommaso Marinetti, 'The Foundation and Manifesto of Futurism', in Charles Harrison and Paul Wood (eds.), *Art in Theory 1900–2000: An Anthology of Changing Ideas*, revised edition, Oxford 2003, p.149.

4. Modigliani enrolled at the Scuola Libera di Nudo in Florence in 1901, passed the Accademia di Belle Arti examination which enabled him to produce copies of works in museums in 1902, and attended the Scuola Libera del Nudo at the Accademia di Belle Arti in Venice from 1903 until the end of 1905.
5. Many of these details are reported by Alexandre in a letter of 1924 to Modigliani's sister Margherita, quoted in Noël Alexandre, *Modigliani Inconnu*, Paris 1993, pp.53–9.

6. This is the number arrived at by Flavio Fergonzi in 'Preliminary Issues for Modigliani Sculptor', in *Modigliani Sculptor*, exh. cat., Museo d'Arte Moderna e Contemporaneo di Trento e Rovereto, Rovereto 2010, pp.21–61.

7. The first *Endless Column* dates to 1918, but the germ of its design can be seen in the small, carved stone base of Brancusi's *Maiastra c.*1912 (Peggy Guggenheim Collection, Venice).

8. Sidney Geist, 'Le devenir de la colonne sans fin', in *Les Carnets de l'Atelier Brancusi*, Paris 1998, p.16.

9. Alexandra Parigoris, 'Modigliani-Brancusi', in *Modigliani et l'Ecole de Paris*, p.83.

10. Alessandro del Puppo, 'Worldly Primitivism, Orientalism for Museums', in *Modigliani Sculptor*, p.67.

11. A reconstruction of the avenue Foch apartment showing this configuration of objects can still be viewed at the Musée de l'Orangerie as part of its display of the Jean Walter-Paul Guillaume Collection. A 1915 exhibition at Maurice de Zayas's Modern Gallery in New York included African sculptures alongside Modigliani drawings, paintings and *Heads* loaned by Guillaume.

12. Jacques Lipchitz, *Amedeo Modigliani*, Milan 1958, p.3; Jacob Epstein, *The Sculptor Speaks. Jacob Epstein to Arnold L. Haskell*, London 1931, p.129.

13. Kenneth Wayne, 'Modigliani, Modern Sculpture and the Influence of Antiquity', in *Modigliani Sculptor*, p.76.

14. See Brancusi's *Caryatid c.*1908 (Museum of Modern Art, New York).

15. See Kenneth Wayne in *Modigliani Sculptor*, pp.76–85.

16. Jacob Epstein, *An Autobiography*, London 1964, pp.46–7.

17. Fergonzi in *Modigliani Sculptor*, p.22.

18. Works by Souza-Cardoso, Albert Gleizes and Fernand Léger were also exhibited in this room.

19. See Alfred Werner, *Modigliani The Sculptor*, London and New York 1962, pp.xxii, xxvi.

20. Fergonzi enquires further as to the possible causes in *Modigliani Sculptor*, pp.56–7.

21. This testimony comes from one of Modigliani's models, Lunia Czechowska, quoted in Emily Braun, 'Carnal Knowledge', in *Modigliani and his Models*, exh. cat., Royal Academy of Arts, London 2006, p.40.

22. Berthe Weill, quoted in Kenneth Silver, ''Too many last words': The Myth of Modigliani', in *Modigliani and his Models*, p.24.

23. Griselda Pollock, 'Modigliani and the Bodies of Art: Carnality, Attentiveness and the Modernist Struggle', in *Modigliani: Beyond the Myth*, exh. cat., Jewish Museum, New York 2004, p.56.

24. Gustave Coquiot, *Des Peintres maudits*, Paris 1924, p.102.
25. Kenneth Wayne, *Modigliani and the Artists of Montparnasse*, exh.cat., Albright-Knox Art Gallery, New York 2002, p.47.

26. Pollock in *Modigliani: Beyond the Myth*, p.61.

27. T.J. Clark, *The Painting of Modern Life: Paris in the Art of Manet and his Followers*, revised edition, Princeton 1984, pp.79–146. The distinction between 'naked' and 'nude' originates in Sir Kenneth Clark, *The Nude: A Study in Ideal Form*, London and Princeton 1956.

28. This is discussed in Carol Mann, *Modigliani*, London 1980, pp.155–6. Ironically, in the 1950s, a public campaign was mounted against the sale of a postcard of Modigliani's own *Nude* 1917, at the Solomon R. Guggenheim Museum, due to its supposedly pornographic content. Pollock in *Modigliani: Beyond the Myth*, p.55.

29. Braun in *Modigliani and his Models*, p.53.

30. Ibid., pp.50, 58.

31. See Simonetta Fraquelli, 'A Personal Universe: Modigliani's Portraits and Figure Paintings', in *Modigliani and his Models*, pp.37–42.

32. This section is greatly indebted to Simonetta Fraquelli's excellent essay, ibid.

33. Ibid., p.34.

34. Ibid., p.36; Emily Braun, 'From The Risorgimento to the Resistance: One Hundred Years of Jewish Artists in Italy', in Vivian B. Mann (ed.), *Gardens and Ghettos: The Art of Jewish Life in Italy*, exh. cat., Jewish Museum, New York 1989, p.138.

35. Silver in *Modigliani and his Models*, pp.25–7.

36. Sickert's preface to the catalogue for the exhibition *Twentieth Century French Art* at the Leicester Galleries, London, in Anna Greutzner Robins (ed.), *Walter Sickert: The Complete Writings on Art*, Oxford 2000, p.614.

Index

First published 2017 by order of the Tate Trustees
by Tate Publishing, a division of Tate Enterprises Ltd,
Millbank, London SW1P 4RG
www.tate.org.uk/publishing

A catalogue record for this book is available from the
British Library
ISBN 978-1-84976-528-2

Distributed in the United States and Canada by
ABRAMS, New York

Library of Congress Control Number applied for

Designed by Anne Odling Smee, O-SB Design
Layout by Caroline Johnston
Colour reproduction by DL Imaging Ltd, London
Printed by Graphicorn Srl, Italy

Cover: Amedeo Modigliani, *The Little Peasant* c.1918
(detail, see fig.54)
Frontispiece: Amedeo Modigliani, *Self-Portrait as
Pierrot* 1915 (detail, see fig.38)

Measurements of artworks are given in centimetres,
height before width, before depth.